韓國繪師的
角色繪製
重點攻略

POINT CHARACTER DRAWING

T A C O

vol.1

U0072720

Prologue

大家好，我是以TACO為筆名，進行創作活動的崔元喜。

在第一本書籍《韓國繪師的動漫角色速繪祕技》之後，我推出了第二個系列《韓國繪師的角色繪製重點攻略》。首先要由衷感謝各位平時的關愛與照顧，讓我能順利推出第二套書籍。

若說第一本書是展示「繪畫過程」的基本繪圖技法，本書便邁向了下一階段，是用以解說「人體的核心重點」的書籍。書中將簡化圖片說明，盡量在圖像中著重標示出最重要的觀念。

我相信，本書尚有許多未盡之處，但我用心製作本書，盼望各位讀者透過閱讀文字與圖像，能夠輕易地理解要點並加以應用。

平時，我就堅信繪圖是否服膺公式都並非重點。縱使以解剖學觀點來看，確實存在著明確的平均值答案，但無論如何，繪畫是用以具現我們的想像、自由表述的工具，因此我認為，畫面是不是有趣、是否擁有合乎情理的詮釋，才是最重要的。

我希望人人都能依照個人追求的畫風為基準，找出作畫的方向，任何人都可以拿起畫筆，帶著自己的想法繪圖創作。繪畫沒有正確解答，《韓國繪師的角色繪製重點攻略》亦只是無數繪畫理論中的一本指南。只要看著文字與圖解，理解書中強調的核心重點，並加以應用、練習，我相信每位讀者的繪畫實力都能往好的方向持續成長。

　　與其將本書中提及的繪畫理論當作絕對的法則，認定「非這麼畫不可」，一一嚴格遵從，我更盼望各位將本書當作能夠輕鬆再詮釋的人體變形指南。甚至可以將書中出現的觀念，以簡易的方式重新應用、詮釋，內化為各位自己的理論，如此一來，繪畫一定能更輕鬆有趣。

　　謝謝大家。

CONTENTS

Part 1

軀幹 body 9

Part 2

手臂 arms 123

韓國繪師的
角色繪製
重點攻略

POINT CHARACTER DRAWING

TACO

vol.1

軀幹＋手臂

韓國繪師的角色繪製重點攻略

Part 1 軀幹

body

當身體和臉部各自朝向不同方向時，
可扭轉頸部中心使整體更自然。

When the body and face are in different
directions, twist the center of the neck
to make it natural.

Q版角色的頸部長度，會隨著體型變化。

For SD（Super Deformed）characters, as the body shape is simplified, the neck length changes.

從正上方觀看軀幹時，背部肌肉和頸部肌肉會呈現菱形。隨著視角變化，菱形也可能被壓縮延伸。

When the body is viewed from above, it has a rhombus shape due to the back and neck muscles. Depending on the angle, the rhombus is drawn in a pressed shape.

當鎖骨向兩側斜上延伸時，看起來就像同時抬起雙肩的動作。

If the collarbone goes up on both sides, it looks like a movement of the shoulders going up together.

在漫畫手法中，為了明確表現出雙肩下垂的感覺，亦會將鎖骨稍微向下繪製。

In a cartoonish expression, the direction of the collarbone is slightly lowered to emphasize the feeling of sagging shoulders.

在肩膀起始的位置繪製出鎖骨稍微向外
突出的部分，可增加人體的細節。

To add extra detail, draw the top of the
collarbone protruding near the starting
point of the shoulder.

斜方肌由後頸處向下延伸，肌肉形狀連接了頭部、頸部、肩膀與背部。

The shape of the trapezius muscle that descends from the nape of the neck connects the head, neck, shoulders, and back.

若從正面觀察，兩側肩膀至頸部的寬度是相同的，那麼由半側面角度來看，便應稍微縮減位於後側的肩膀寬度，比位於前側的肩膀更窄。

If the width of the left and right sides from the neck to the shoulder is the same in the front view, it is better to reduce the width of the shoulder located at the back slightly than the one at the front in the three quarter view.

肩膀處的三角肌，由側面可以劃分為三個區塊／正面、背面各兩個區塊。

The mass of the deltoid muscle is divided into three on the side, and two on the front and back.

若將上半身視為一個長方體，就能
掌握好隨著視角變化，手臂和肩膀
被軀幹遮蔽住的部分。

If you think of the upper body as
a rectangle you can grasp the
positions of the arm and shoulder
that are hidden on the opposite
side of the viewing angle.

繪製背部的時候，只要好好表現出肩胛骨，就能畫出帥氣的背影。

When expressing the back, a nice back figure is drawn even if only the shoulder blade (scapula) is well expressed.

肩胛骨呈現三角形，手臂運動時也會隨之移動。

The scapula has a triangular shape and moves together when the arm moves.

肩胛骨附著於背部，隨著軀幹的形狀
呈現稍微彎曲的型態。

The shape of the scapula on the back
is attached in a curved state according
to the shape of the body.

當手臂垂直身體舉起時，由於肩胛骨的骨頭
形狀，背部上方會稍微突出。

When the arm is raised vertically, the upper
part of the back protrudes slightly due to the
scapula, which is the shoulder bone.

繪製胸腔部位時，肋骨的形狀應
畫得有如一顆雞蛋狀。

The chest area is drawn by
recalling the shape of an egg,
which is the form of the ribs.

從側面觀看時，肋骨是以傾斜的角度，
呈現稍微背壓扁的型態。

The ribs viewed from the side are slightly
pressed at a tilted angle.

以成人而言，繪製胸部時，胸腔大小大致與頭部相近，或比頭部略小一些。

When drawing a chest size based on an adult, draw it similar to or slightly smaller than the size of the head.

手臂放下和高舉時，胸部的形狀
會隨著肌肉拉伸有所不同。

The shape of the chest when the
arm is lowered and when it is
raised changes as the muscles
are pulled.

胸部的肌肉愈大，胸部的線條就愈
需完整延伸，連接到腋下；若胸部
肌肉較小，底部線條只需適當勾
勒，表現出一小部分即可。

When drawing large chest muscles,
connect the chest line to the armpit.
The chest line on a smaller chest
does not reach the armpit nor does
it connect at the center.

繪製胸部基礎形狀時，男性和女性的胸部曲線有所不同。

In the basic form of the chest, the curves of the chest of men and women are drawn differently.

女性角色胸部起始的位置比想像中更低，約莫是從男性胸部的中間位置開始繪製胸部的曲線即可。

the female character's chest starts lower than you think, so the shape of the curved breast is drawn from the middle of the male breast.

女性胸部的形狀主要是由脂肪
組織形成。

Women's breasts are made up
of fatty tissue.

由於脂肪附著在胸部肌肉兩側末端，因
此將胸部的肌肉考慮進去，會更容易繪
製女性的胸部線條。

Since fat is attached to both ends of a
woman's chest muscles, draw the chest
line with reference to the chest muscles.

由於女性胸部組成並非肌肉，而是脂肪，因此上方起始的位置不會改變，影響胸部大小的是胸部底部的位置。

A woman's chest is fat, not muscle. Therefore, the position of the upper chest does not change according to the size of the chest, but the lower chest does.

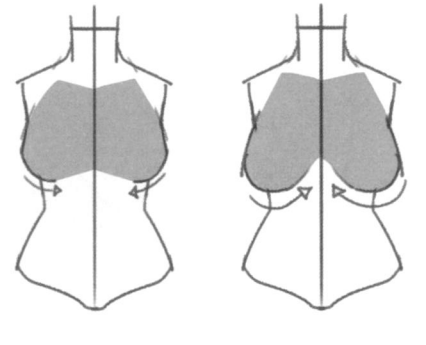

胸部底部的線條長度會隨著乳房大
小有所不同。

Depending on the size of the
breasts, the length of the lower
breast line should be changed.

繪製女性胸部線條時，不要忘記表現出兩側腋下和胸部底下的三角形空間。

When drawing the silhouette of breasts, it helps to imagine three triangles, two in the armpit and one at the center of the chest.

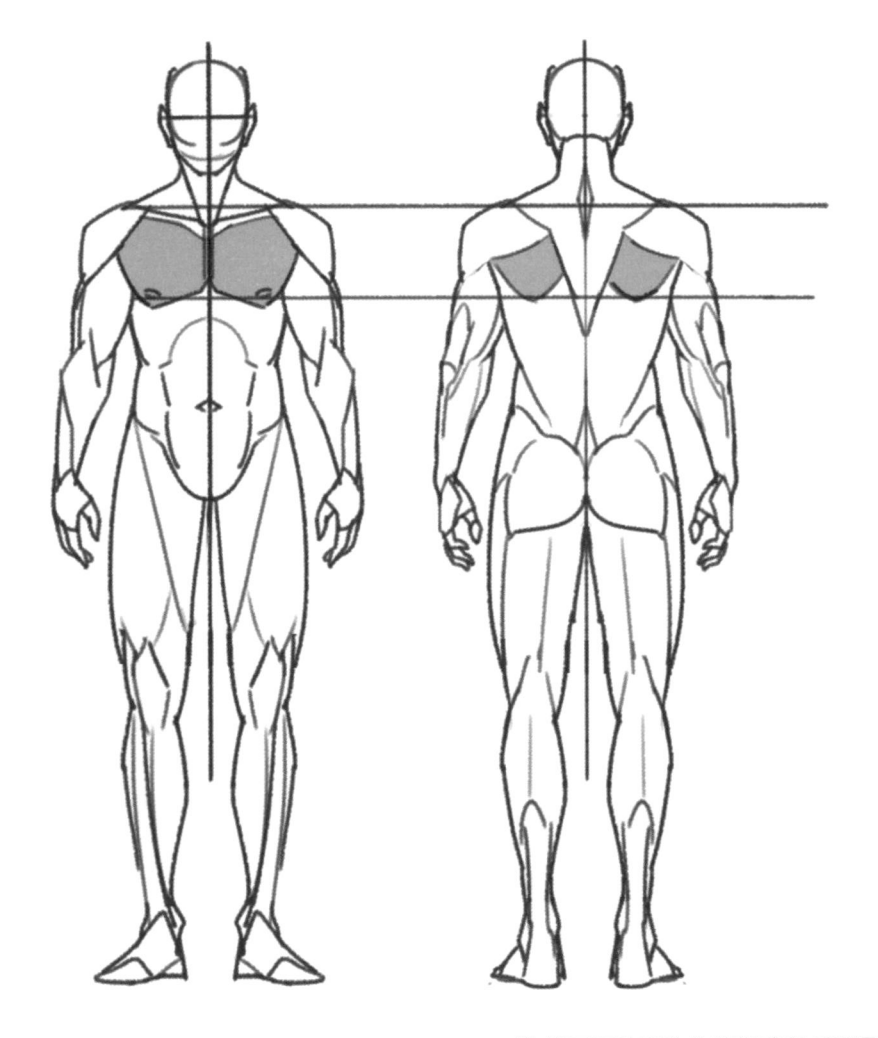

胸部正面乳頭的位置與背部肩胛骨底部位置一致。

The position of the nipple on the front chest and the position of the scapula on the back are the same.

以軀幹中央為基準，乳暈的位置稍微偏向外側，乳暈的大小、型態與位置皆有個體差異。

The areola is located on the outside of the chest in relation to the center of the body. There are individual differences in the size, shape and location of the areolas.

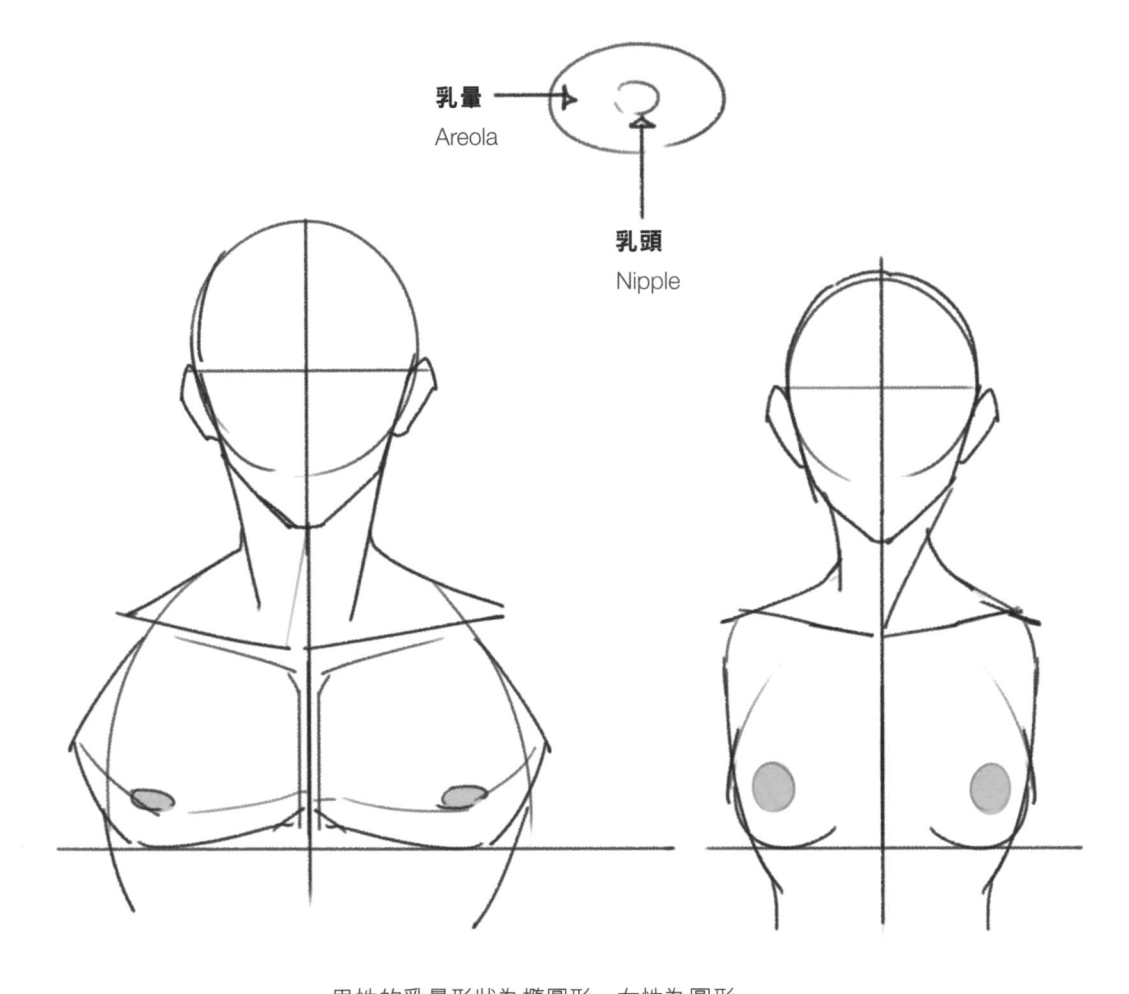

乳暈
Areola

乳頭
Nipple

男性的乳暈形狀為橢圓形，女性為圓形。

The shape of the areola is oval for men and circular for women.

腋下部位的手臂會遮擋住一部分軀幹。

Part of the body on the armpit side is covered by the arms.

高舉手臂時，腋下的線條形狀應接近一個傾斜的菱形。

When the arm is raised high, the armpit line is drawn in the shape of a tilted rhombus.

高舉手臂時，胸部外側線條會自然
延伸至腹部的肌肉線條。

When the arms are raised high, the
outer line of the chest and the line
of the abdominal muscles naturally
connect.

腹外斜肌會形成三道曲線延伸至腹肌<1>的位置。

Draw three curves at the location of the abdominal muscles <1> to create the flow of the external oblique abdominal muscles.

表現上半身肌肉時，腹肌側面肋下
部位的線條應交錯描繪，勾勒出腹
部外側斜向的肌肉。

As an expression of the upper
body muscles, the external oblique
abdominal muscles are expressed
by crossing lines in the flank range
next to the abdominal muscles.

若欲畫出漂亮的腹外斜肌，只需在肌肉交錯處繪製出不同的角度即可。

As a way of expressing the external oblique muscles you can change the angle of the muscles at the point where the muscles intersect.

上半身的肋骨底部與手肘彎曲部
位大致齊平。

The bottom of the ribs and
the elbow should be aligned
horizontally.

從側面觀察時，腹肌的寬度比想像中更窄。

The width of the abdominal muscles on the side of the body is narrower than you might expect.

腹肌寬度約與正面臉部的橫向同寬。

The width of the abs is similar to the width of the front face.

若軀幹部分的肌肉健壯發達，只要將腹肌寬度畫得比臉部更寬即可。

If the muscles in the body are large, set the abdominal muscles larger than the width of the face.

愈是細分腹肌的塊狀，愈能細緻表
現出肌肉的形狀，也愈複雜。

The more defined the mass of
the abdominal muscles, the more
detailed and complex the muscle
shape becomes.

此時，周圍肌肉也應盡量以相同
方式增加細節、區分塊狀。

The surrounding muscles should
also be defined in a similar way.

在側面或接近側面的半側面時，腹肌的輪廓
會更容易影響軀幹輪廓；除此之外，一般由
肋骨及腰部線條形成軀幹輪廓。

For the silhouette of the abdominal muscles, it affects the silhouette when it is a side view or a three-quarter view close to the side view. Other than that, you can create a silhouette of the abs with the silhouette of the ribs and waist line.

在肋下向側邊彎折的情況下，須考慮到肋骨底部和骨盆的頂部位置，繪製出突出的部分。

When the torso is folded to the side, the mass between ribs and pelvis protrudes slightly.

掌握側面頭部大小與上半身寬度的比例,就能表現出與年齡相符的角色形象。

By measuring the width of the upper body in proportion to the size of the head from the side profile, you can express a character at different ages.

繪製側面時，在上半身後側加入三角形
面積，能表現出軀幹些微扭轉的感覺。

In the side view, drawing a triangular area
on the back of the upper body will make
the upper body look slightly twisted.

在側面加上手臂時，不應繪製在軀幹正中間，而是更貼近背部的位置。

In the side view, the arm is attached close to the back side, not the center of the body.

從側面觀察時，整體構造上背部
線條會向內凹折、臀部向外凸出。

Looking at the side of the body,
the back line goes in and the hips
come out.

繪製背面的半側面時，背部中
央同樣會形成凹陷的曲線。

The central flow of the back is
concave when drawn from the
three quarter rear view.

觀察男性的側面，上半身寬度
會比頭部更寬。

In the man's profile, the width
of the upper body is set larger
than the head.

觀察女性的側面，上半身寬度根
據胸部大小不同，會比頭部略寬。

In the woman's profile, the width
of the upper body is set slightly
larger depending on the size of
the breast.

在側面角度，由於手臂自然
下垂，會遮擋住背部凹陷部
分的輪廓。

In the side view, the concave
silhouette of the back is
covered by the lowered arm.

繪製背部脊椎的中心線時，須考慮到腰
部的凹陷處，來表現長方體的背面。

When drawing the center line of the
spine in the rear view, a rectangle is
expressed in the center of the back,
taking into account the space where the
waist goes inward.

從背面觀察時，當上半身背部彎曲
起來，頸部長度會由於透視關係顯
得較短。

When looking at the upper body
with a bent back from behind, the
length of the neck becomes shorter
due to perspective.

背部肌肉（背闊肌）由腋下延伸，匯聚於臀部。

There are back muscles (latissimus dorsi muscle) that gather from the armpits to the natal cleft.

比起手臂貼合臀部，使手臂稍稍往
臀部兩側展開，會更富力量感。

Leaving distance between the
hands and thighs creates a
powerful silhouette.

繪製手撐下巴的姿勢時，手肘的
位置相當重要，下巴至手肘位置
大約等同一個頭部的長度。

When drawing a character with
the head resting on the hand, the
position of the elbow is important.
The distance between the chin and
the elbow should be proximately
the size of the head.

將手肘支撐於大腿上的時候，須使上身彎
曲，創造出一個頭部的長度。

If the elbows are placed on the thighs,
lower the upper body to create a head-
sized space.

在腿部併攏的狀態下，繪製出手臂的
動作，可以強調出手臂的動態。

If there is movement in the arm while
the legs are gathered, the feeling of
movement in the arm is emphasized.

手臂若向前伸展，則從背部觀察
時，須優先繪製背部線條。

If the arm is stretched forward
in the back view, the line of the
back is prioritized.

手臂若向後彎曲，則從背
部觀察時，須優先繪製手
臂線條。

If the arm is extended
backwards when drawn
from behind, the arm line
takes precedence.

若將手腳繪製得比臉部更大，
能創造出具有漫畫風格、塊狀
質感的人體比例。

Drawing the hands and feet
larger than the face creates a
cartoon-like style with a lumpy
body proportion.

此時指尖部分也以厚重的感覺畫成略
帶方塊狀，效果更佳。

When doing this, draw the tips of the
fingers in a boxy fashion.

讓人物擺出出拳動作的時候，視線與
出拳方向一致較佳。

When throwing a punch, the eyes are
directed toward the stretched fist.

繪製上半身時，可以大致
分為胸部、腹部、骨盆三
個區塊。

When drawing the upper
body, divide it into three
large chunks: chest,
stomach, and pelvis.

以上半身而言，胸部稍微靠前，骨盆則略向後傾。

In the upper body, the chest goes forward and the pelvis goes backward.

上半身須繪製出像弓一樣彎曲的弧度，才會顯得穩定。

To draw a stable upper body, curve the torso and pelvis in a bow-like shape.

當上半身向後劇烈彎折時，上腹部會由
於肋骨的緣故，形成突出的輪廓。

When the upper body is tilted far
backwards, the rib bones protrude from
the upper part of the stomach.

稍微賦予上半身前俯或後仰的動作，
也能創造出動態的感覺。

A dynamic flow can be created just
by moving the upper body slightly
forward or backward.

當上半身前彎時，胸部與腹部都會彎折起來，但由於胸部比腹部彎曲得更多，因此從其他角度觀察時，胸部的面積會被大幅省略。

When the upper body is bent, the chest and belly parts are bent. Since the chest is bent more than the belly, a lot of the chest area is omitted when viewed from a different angle.

從半側面觀察上半身前彎的情況，後背部
分由頸部至骨盆形成很大的曲線，前胸也
會在腹部附近形成一個凹折的曲線。

When the upper body is bent at the
three quarter view, the back is drawn in a
singular curve from the neck to the pelvis,
and the chest side is expressed with a
concave flow centered on the stomach.

當上半身前俯得愈深，曲線會愈
接近折疊起來的感覺，但胸部會
由於透視顯得更窄短。

If the upper body is bent further,
the bending flow is the same, but
the chest area becomes shorter
due to perspective.

若欲繪製出具動態的上半身曲線，可將身體一側勾勒出像弓一樣的大弧度曲線，另一側以腰部為基準畫出凹折的曲線。

To draw a dynamic upper body, create a bow-like curve on one side, and a concave curve on the other that folds inwards at the waist.

<**男性**>
Man

<**女性**>
Woman

其中一個能輕鬆表現出男性、女性角
色上半身的技法，就是在腹側腰際部
分的輪廓形塑出差異。

One way to easily differentiate the
upper body of a male and female
character is to change the silhouette
of the waist.

當然，無論性別，皆創造出更多細微
的變化會更好。

Even a slight change in the silhouette
can make a difference.

上了年紀的角色往往背部曲線彎折、腹部隆起，面部角度也會維持低垂狀態。腿部在膝蓋處稍微彎曲。

For older characters, bend the back line, bulge the belly and bend the angle of the face down a little. The legs also bend at the knees slightly.

肋骨（接近胸部）和髖骨（接近
骨盆）的寬度是相同的。

The width of the ribs (near the
chest) and the hip bones (near
the pelvis) are the same.

有一個方法能輕鬆決定上半身的寬度。女性的肩膀與骨盆同寬，男性的骨盆則比肩膀略窄即可。

As an easy way to measure the width of the upper body, draw the width of the shoulder and pelvis equally for women, and draw the pelvis a little smaller than the width of the shoulder for men.

平均而言，成人臉部的長度大致
等同於肋骨、骨盆的寬度。

On average, the length of an
adult's face is similar to the width
of the ribs and pelvis.

當然了，將性別、年紀、體態以
漫畫風格的表現出來時，長寬都
會有所差異。

Of course, the length and width
may be different depending on the
character's gender, age, physical
appearance, and whether or not
they are drawn in a cartoon style.

將鎖骨與骨盆的水平線扭轉得愈
多，上半身或整個人體的曲線就
愈具動態感。

The more the horizontal lines
of the collarbone and pelvis are
twisted, the more dynamic the
flow of the (upper) body changes.

若欲輕鬆繪製出上半身的扭轉，可將胸部與骨盆分別轉往不同角度，再將各個角落延伸連接，即可繪製出腰部。

In order to draw a twisted upper body, vary the angles at which you draw the chest and pelvic sections and then connect their corners to create the waist.

當軀幹扭轉時，以側面為基準區分
出胸部、腰部、骨盆，再分別表現
出正面與背面。

When twisting the body, create a
clear division between the chest,
waist, and pelvis to show the front
and back sides based on the side.

繪製骨盆時，容易令人聯想起
內褲的形狀，對準兩側的孔洞
表現出腿部即可。

The pelvis is drawn by recalling
the shape of underpants, and
the legs are attached to the
holes on both sides of it.

繪製腰部與骨盆時，可仔細描繪出腰際因骨骼
稍微突出的細節。

When drawing the pelvis under the waist, the
bones stick out slightly.

連接腰部與腿部時，可明確勾勒出骨盆構
造上輕微凹陷的曲線，表現出性感的臀部
線條。有時為了刻意展現出這部分，亦會
將褲頭位置畫得偏低。

As for the part from the waist to the legs,
you can create a sexy pelvic line by clearly
expressing the line that is bent due to
the pelvic structure. To show this part
intentionally, you can draw it with the pants
down a little.

別忘記留下褲襠處的空間。

You need to make space on the crotch side.

根據人體體態與姿勢，正面角度有時也可以透過褲襠看見少部分臀部。

Depending on the body and pose, the buttocks may be slightly visible between the crotch in the front.

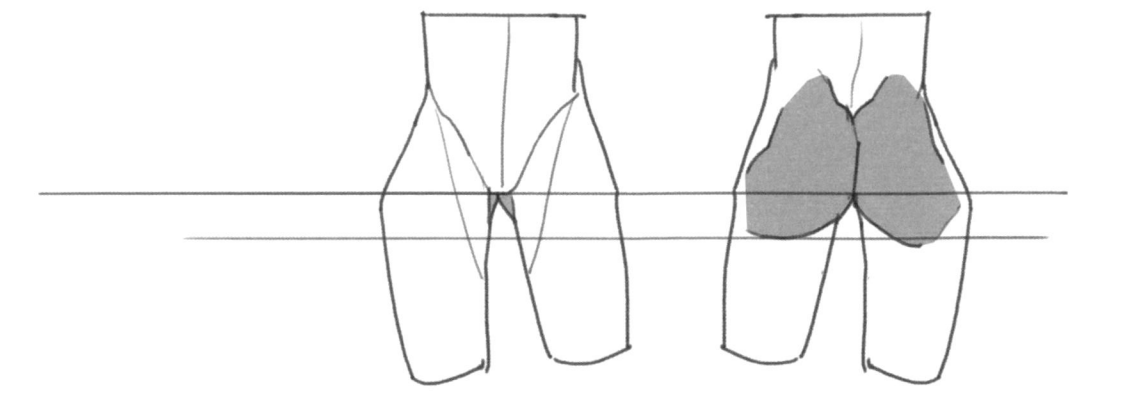

腿部遮擋住大部分軀幹的姿勢往往較難繪製。刻畫這類姿勢時，應該先連同骨盆一起繪製出來，再畫出腿部較佳。

When drawing complex postures, it helps to draw the legs after the pelvis.

將腿部抬起、展現出臀部線條的
時候,臀部輪廓並不是渾圓的。

When the hip line is visible as the
leg is raised, the silhouette is not
round.

若臀部觸地,須按照地面的透視,
使臀部輪廓與地面保持水平。

If the hips touch the floor, make the
hip silhouette horizontal to match
the floor perspective.

從背面觀看時，男性的臀部比肩膀窄小，女性的臀部寬度大致與肩膀相近。

When viewed from the back, the hips are set narrower than the shoulders for men, and the hips and shoulders are positioned similarly for women.

若要將臀部分成兩半，須考慮到背面面積的中心軸線再進行區分。若熟練了透視的方法，就能輕鬆以曲線劃分出來。

When dividing the hips in half, refer to the center axis of the hip area. If you are familiar with perspective, divide the hips into curves.

若曲線還難以掌握，可以單純地想像成方形，以背面中軸為基準，將臀部豐滿的感覺繪製出來。

If it is difficult to divide the hips into curves, think of a simple square shape and add volume on the hips based on the center axis of the back of the body.

繪製腿部向後抬起的動作時，臀部
曲線和大腿線條須符合透視。

When the leg is lifted back, draw
the hip line and thigh line to match
the perspective.

腿部彎曲時，想像後腳跟與臀
部的位置相近，會更容易繪製。

When the legs are folded, the
heels and the hips should align
with one another.

大腿正面大致分成三個區塊，由於外表覆蓋著皮膚，分區線條不會過於強烈。

The front part of the thigh is divided into three large sections and the defining lines weaken as the skin is covered.

若使腿部的曲線在膝蓋處併攏，能創造出難以支撐、較為乏力的感覺。

Drawing the knees together gives the impression that the character has run out of energy.

由於腳應比手更大，須留意
不能繪製得過小。

Be careful not to draw the
feet smaller than the hands.

從正面可看見的腳部（腳背）長度，
只要對比臉部下巴處，就能大致掌握
好，不至於顯得突兀。

As a method of estimating the length
of the foot (instep) seen from the
front, match the length of the lower
part of the face.

當人體動作的雙腳併攏，或是會遮擋住
單側的腳部時，應盡可能考慮到遮蔽
處，仔細繪製出剩餘可見部分較佳。

When drawing legs that are gathered, or
when one leg covers the other, it helps
to imagine drawing the whole of the
hidden leg.

為了掌握好人體整體的比例，比起
手臂，應優先繪製出腿部，才能更
好地觀察整體的動作。

In order to estimate the proportion
of the whole body, it is better to
draw the legs before the arms to
see the overall flow of movement.

以骨盆為基準，可以使畫面後側的腿部向前或向後伸展開來，表現出骨盆的曲線。

If the leg behind the pelvis is positioned forwards or backwards, it will create a slightly twisted pelvic flow.

繪製踢腿動作時，可使上半身扭轉至
腿部的反方向，增加動態感。

When drawing a kick posture, twist
the upper body in the opposite
direction of the foot.

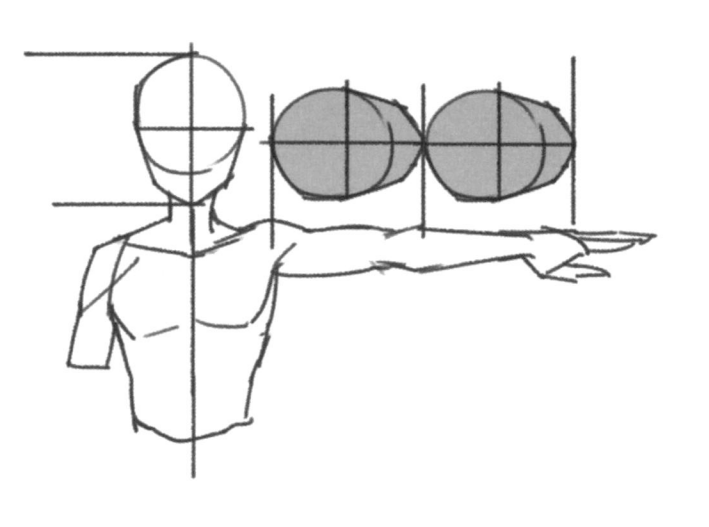

繪製六頭身比例時，手臂至手背長度約取兩個臉部的長度較為恰當，腿部則大約等同三個臉部的長度。

When drawing the proportion of the 6-head figure, the length of the arms to the back of the hand measures two heads and the length of the legs approximately three.

若是Q版角色的情況，當比例較小，使
頸部縮減、頭部直接與上半身相連更好。

In the case of SD(Super Deformed)
characters, the smaller the body
proportion, the better it is to connect
the head directly with the upper body
removing the neck.

由於沒有頸部，可將軀幹繪製成雞
蛋形狀，愈往臀部愈寬大。

Since there is no neck, the body is
made in the shape of an egg that
gradually widens toward the hips.

雖然角色的體型皆不相同，但平均而言，使腿部粗細約等於手臂的1.5至2倍，會更容易繪製。

Although this may vary depending on the character, you can measure the proportion of the legs in relation to those of the arms. Legs will be 1.5 to 2 times thicker than arms.

欲表現肌肉時，須留意不可只著重勾勒
上半身的肌肉線條，導致下半身肌肉過
於單調。上半身與下半身應以相同的感
覺繪製出肌肉線條。

The point to be careful when expressing
muscles is that only the muscle lines of
the upper body are expressed and the
muscle lines of the lower body are often
drawn flat. You should draw the lines of
the muscles with the same feeling on
the upper and lower body.

縱使是相同的人體，若想像浩克一樣凸顯出肌肉時，將臉部繪製得較小，手腳放大，就能強調出人體的肌肉構造，效果極佳。

To create a Hulk like figure, where the muscles are emphasized and exaggerated, make the head smaller and hands and feet bigger.

根據想要強調出的肌肉部位不同，就
能繪製出有趣又多樣化的體型。唯須
留意不能太過誇張，否則可能會影響
畫風，變得有些突兀。

Depending on which part of the
muscles you emphasize you can draw
a variety of interesting body shapes.
However, over-doing this may create
an awkward looking body shape.

當人體的輪廓愈單純，漫畫風格的感覺就愈強烈。
相反地，為了繪製出具有細節的輪廓，就需要更理解人體的構造與肌肉。

The more the body silhouette is simplified, the stronger the more
cartoonish the body becomes. Conversely, in order to create a detailed
silhouette, it is necessary to understand the structure of the human body
and the muscle mass.

胸部肌肉的尺寸和臀部肌肉的
長度大致相同。

Adjust the size of the chest
muscles and the length of the
hip muscles similarly.

女性臀部的長度約比胸部肌肉的
尺寸略大一些。

For women, set the length of the
hips slightly larger than the chest
muscles.

若想輕鬆繪製出背影，可先用與正面相同的
手法勾勒輪廓，在背部中央畫出脊椎線條，
再以襠部為基準繪製出臀部的豐滿感即可。

To easily draw the back of the human body,
draw it in the same way as the front view,
then express the spine line in the middle of
the back and create a sense of volume on
the hips based on the crotch.

根據人體各部位的重點部分繪製出傾斜度，就能在人物上套用透視感。

Perspective can be applied to a character by creating a slopeat each point of the body.

依據不同視角高度的透視線為基準，
決定地面的面積或傾斜度。

The area or slope of the floor is
determined by the perspective line at
eye level.

繪製側面的站姿時，留意使臀部線條與
小腿線條保持於同一垂直線上，可增加
穩定性。

In the side profile of a standing position,
it is stable if the hip line and the calf line
are matched to the vertical line.

若欲繪製出半側面穩定的站姿，比起使臉部趨前，應將骨盆畫在更靠前的位置。

When drawing a stable standing position in the three quarter view, the pelvis is positioned more forward than the face by sticking out the upper body a little bit

若只轉動頭部向後張望，應只能看見
臉部的側面；若連同上半身稍微向後
扭轉，則可看見臉部的半側面。

When drawing a look-back posture
when only the head is turned, the
whole side of the face is visible. if the
upper body is slightly twisted, up to
three-quarters of the face is visible.

若手腳部位由於透視遭到遮蔽，比起完全遮擋住，繪製出未被遮蔽的細節，不僅能使整體型態更加豐富，也能確實地傳達動作的資訊。

Even if the hands and feet could be covered by the perspective, it is better to make them visible. This improves the form and conveys the sense of movement better.

以背部或臀部倚靠物體時，由於折點不同，
應由欲繪製的角度去掌握彎曲的折點。

When leaning on the back or hips, the
bending point is different. Therefore, it is
better to identify the bending point from
the angle you want to draw.

利用關節或軀幹的輪廓畫出Ｚ字型的
線條，便能製出更富動態、更自然的
姿勢。（無關手臂的動作）

Creating a zigzag flow between
different sections of the body will
produce a dynamic shape. (The flow
of the arms is not relevant)

當上半身劇烈後仰時,應將骨盆前
推,並使腿部向後移動。

When the upper body is tilted
far back, the pelvis should come
forward and the legs should be
pulled backward.

縱使只有一隻腳向後踩,看起來
也會更穩定。

Even if only one leg is pulled
back, it will look stable.

在集氣的姿勢下，使肩膀與膝蓋維持在
同一垂直線上，會顯得更穩定。

This posture gives an impression of
concentration. The shoulders and knees
are vertically aligned in a stable and
strong posture.

若腳部位置比前彎的上半身更靠前，就會
形成俯身抵禦的姿勢；若腳部位置比前彎
的上半身靠後，則會形成前衝的動作。

To create a crouching posture, place
the foot in front of the bent upper body.
Placing the foot behind the bent upper
body creates a forward motion.

繪製富有動態的姿勢時，只要將身體的
中軸稍微傾斜，就能更富動感。

When drawing a dynamic pose, tilting
the central axis a little will make the
movement more active.

就算是相同的動作，只要改變衣物的曲線，也能創造出多樣化的動態感。

Even with the same posture, you can create a variety of dynamic movements by changing the flow of the clothes.

繪製男性、女性人體時，應將腰部與骨盆作為重點繪製出差異，依據性別不同，胸部的型態等細節部分也應一同繪製出來。

When drawing the body of a man and a woman, you can change the silhouette by focusing on the shape of the waist and pelvis. The shape of the chest will also differ.

手臂和腿部大幅彎曲的情況下，應仔細
畫出手肘和膝蓋突出的骨頭形狀。

If the arms and legs are folded a lot,
express the shape of the protruding
bones of the elbows and knees.

若彎曲的角度不大，骨頭突
出的感覺也會較弱。

If the folding strength is
weak, the protruding feeling
will also be weakened.

持握重物時，可將桿身的中央位置靠放在肩上，再用手搭著或握住下半部。

When holding a weighty tool, the middle position of the pole is placed on the shoulder and the lower part is supported or held by the hand.

以雙手持握時，將雙手抓握的間隔距離放寬，會顯得更穩定。

When holding with both hands, widen the space between the hands to create a sense of stability.

當繪製以身體為中心的低角度鏡頭時，應先畫好軀幹，並由臉部圓形的左右兩側與鎖骨處相連，延伸出頸部，後續就能更輕易地畫出下巴了。

For a low angle where the body is centered, draw the body first, then connect the neck from the left and right ends of the circle of the face to the collarbone, and add the chin line later.

韓國繪師的角色繪製重點攻略

Part 2 手臂

arms

在胸部內側，嵌有一塊三角形的肩膀區塊。

The area where the shoulders meet the chest is set as a triangle.

<前>
<Front>

<後>
<Back>

由於背部肌肉的緣故，前後兩側的肩膀型態
有些許不同。

Because of the back muscles, the shape of
the front and back of the shoulder is slightly
different.

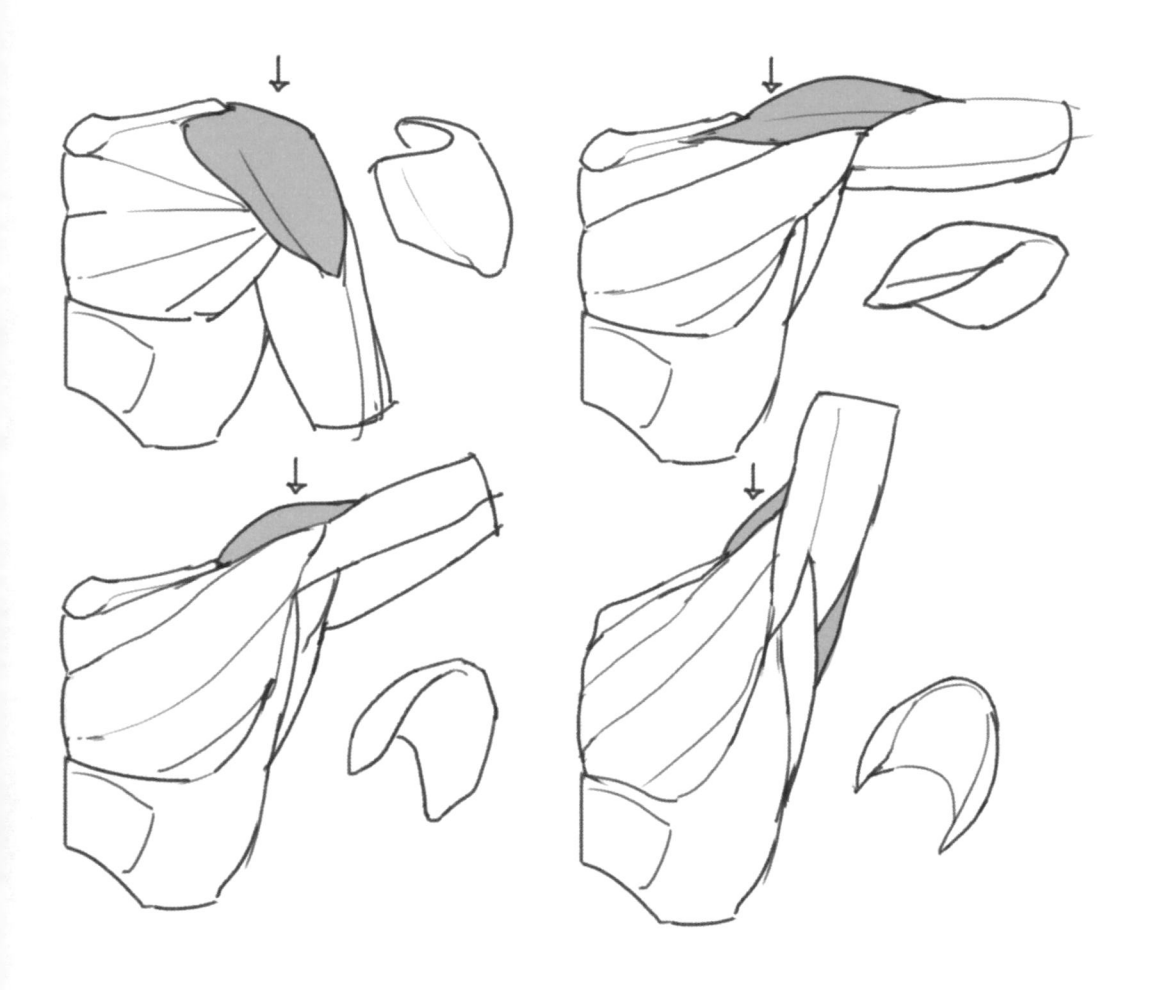

朝正面舉起手臂時，肩膀的肌肉會
向後翻，可見面積隨之減少。

As the shoulder muscles move
back when the arms are raised, the
area where the shoulder muscles
are seen from the front decreases.

手臂並非完全垂直，整體線條由
肩膀至手肘部分會稍微向外，由
手肘至手腕則再向內彎。（只需輕
微的彎折就很自然）

The arm does not flow vertically
down. The flow is outward from
shoulder to elbow and it curves
inward from elbow to hand. (The
flow will only look natural when it
bends slightly)

從側面觀察，肩膀至手肘部分線條垂直向下，
手肘至手腕則會稍微向前彎。

On the side, the flow is vertical from the shoulder
to the elbow and slightly deflected forward from
the elbow to the hand.

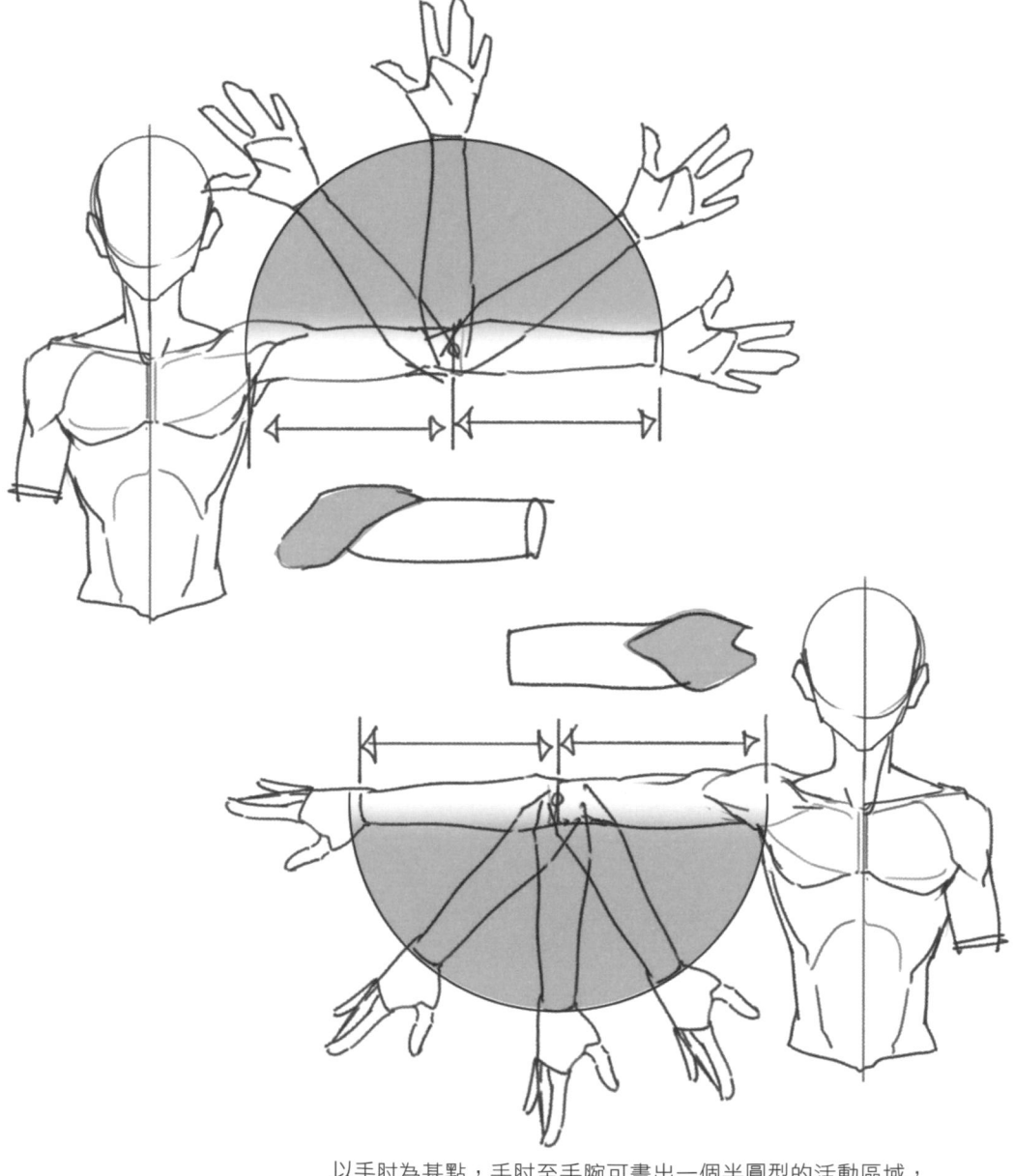

以手肘為基點，手肘至手腕可畫出一個半圓型的活動區域，
依據運動方向（上／下）的不同，肩膀的型態也有所不同。

The part from the elbow to the wrist moves in a semicircle,
and the shoulder shape appears differently depending on the
direction of movement (up/down).

手臂由伸展至彎折，二頭肌的
輪廓會有所差異。

The silhouette of the biceps
changes depending on whether
the arms are extended or
folded.

上臂與手肘連接的部位為
一塊拱形的肌肉。

The upper arm has an
arch-shaped muscle
attached to the elbow.

在與手臂等長的圓形區域中畫出拋物線，在繪製動作時，即使手臂的位置隨著動作變化有所改變，也能輕鬆決定手臂的長度。

To keep the length of the arms consistent when moving to different positions, draw a parabolic line in a circle to act as a reference point.

從肩膀（鎖骨末端）至手肘的長度，
與手肘至指節起始處的長度是等長的。

The length from the shoulder (the point
where the collarbone ends) to the
elbow and the length from the elbow to
the beginning of the finger joint are the
same.

三角肌（肩膀）的長度和肩膀至手肘的長度為1：1。

The length of the deltoid muscle (shoulder) and the
length from the shoulder to the elbow are one-to-one
ratios.

下臂
The lower arm

上臂
The upper arm

雖然上臂與下臂等長，但隨動作
變化加入透視效果時，兩端的長
度也會改變。

The upper and lower arms on
both sides are the same length,
but if perspective is applied as
movement occurs, the length of
both sides can be different.

手臂運動時，若上臂緊貼內側、靠近身體會比較不自然，繪製時讓上臂朝外、遠離軀幹，會顯得更穩定。

When the arm is moving, drawing the upper arm toward the inside of the body is awkward, so it is better to angle the upper arm away from the torso.

由於手臂多半往斜線方向延伸，決定手臂的角度時，
須考慮到上半身的傾斜度。

Generally, when the arm is tilted in a diagonal direction,
the angle of the arm is set with reference to the tilt of
the upper body.

當手臂彎曲時，會在肩膀和手腕之間形成一個空間，
這個空間的寬度約莫與手掌同寬即可。

Folding the arm creates space between the shoulder
and the wrist, and the width of this space can be
thought of as the width of the palm.

當雙手背在腦後時，由於透視效果，
手臂肌群的塊狀也會有所不同。

When holding the back of the head
with both hands, the shape of the
mass varies depending on the
perspective of the arms.

當手臂直指向畫面正前方，透視效果就會使下臂顯得較短。（上臂亦同）

The more forward the arm is, the shorter the lower arm looks due to perspective. (It is the same with the upper arm)

肋下部位與手肘彎曲處愈貼近，上、下臂的透視感
就愈強烈。

The closer the side of the body and the bent part of
the arm the more perspective the upper and lower
arms are.

從半側面觀察上半身後方手臂的位置,就能察覺從正面觀看時,
手臂擺放出什麼樣的動作。

When drawing the upper body in the three quarter view, the flow
of the posterior arm can be used to predict the shape of the other
arm at the front.

若想營造出具動感的感覺，最好在雙臂都加上動態。

To make the arms dynamic, it is better to create a flow in both arms.

當手臂強烈地伸展時，可以以漫畫風格的表現手法，讓手肘部位呈現稍稍逆著關節運動方向彎曲的感覺。

When the arm is stretched out forcefully, it is good to create a slight bend where the forearm and the upper-arm meet in a cartoonish style.

將手臂彎曲舉起時，在畫面上可將手肘斜向呈現出來，看起來更有立體感也更穩定。

When the arm is folded up, draw the elbow at an angle from the screen to create a three-dimensional and stable effect.

為了強調出手臂彎曲時手臂肌群的塊狀感，可在手腕彎折處和手臂內側勾勒出相同的肌肉曲線。

In order to express the mass of the folded arms well, the curve of the inside of the bent arms and the curve of the wrist are drawn equally.

肱橈肌（下臂肌肉之一）的構造
連接著拇指，根據拇指運動方向
的不同，肌肉也會隨之扭轉。

The brachioradial muscle (one
of the lower arm's muscles) is
attached to the thumb, so the
muscles twist in the direction of
the thumb movement.

隨著下臂的轉動，有時手臂肌肉並不易描繪。只要使黃色標示的部分肌群，隨著拇指方向扭轉，就比較容易表現了。

It is sometimes difficult to draw arm muscles when the lower arm is rotating. Turning the yellow marked muscles to the direction of the thumb makes it easier to express arm muscles.

只要想像手肘的線條和小指是相連的，就能更輕鬆表現出靈活轉動的手肘。

To draw fluid changes in the elbow, imagine a line that connects the elbow to the little finger.

依據手肘凹折的曲線方向差異，可觀察
到手臂是向後或向前伸展的。

Depending on the direction of the curve
at the elbow, the arm appears to move
forwards or backwards.

若能強調出下臂上稍微突出的三角形輪廓會更好。
（實際上這是因肌肉型態形成的結構。）

It is good to express a triangular silhouette that protrudes
slightly on the lower arm. (This is actually a structure
made according to the shape of the muscle)

上臂
The upper arm

下臂
The lower arm

手背
The back of a hand

繪製手臂青筋的時候，血管線
條會沿著手背、下臂、上臂依
序顯現出來。

When drawing veins on the
arm, the veins gradually appear
in the order of the back of the
hand, the lower arm, and the
upper arm.

手腕應繪製成稍微壓扁的橢圓形。

Draw the wrist in a slightly pressed oval shape.

由於骨頭的形狀，手腕外側會形成稍微突出的輪廓。

In the case of the outer part of the wrist, a silhouette that protrudes slightly from the bone is created.

由側面觀察時，手腕外側的上半部也有些許突出。

In the side view, the upper part of the outer wrist protrudes slightly.

隨著角度不同，有時突出的感覺並不顯著。

At certain angles the wrist does not appear to protrude.

手背與手腕的平面並非一直線，
而是有稍微陷落的感覺。

The back of the hand is not
straight with the wrist, but slightly
lowered and bent.

當手掌抵著地面或牆面的時
候，手腕雖然能彎折成直
角，但在沒有支撐物的情況
下，將手腕彎折處畫成鈍角
會更自然。

When touching the floor or
wall, the wrist can be bent
at a right angle. However, it
looks more natural to draw
with an obtuse angle when
bending the wrist without an
object.

手腕可以往小指方向轉動四十五度。

The wrist can be bent at an angle of 45 degrees in the direction of the little finger.

若要為動作賦予生動感，可以讓手腕與手指彎曲的角度各有不同。

Bend the wrist and finger angles in different directions to make finger movements more lively.

當手掌前後凹折時，請留意四邊形側面須沿著角度彎折、面積應維持一致。

When the hand is bent back and forth, note that the area on the side of the square is consistent with the angle of the curve.

手腕的寬厚程度大致與食指、中指、無名指三指的寬厚度一致。

The thickness of the wrist is similar to the thickness of the area of the middle three fingers - the index, middle, and ring fingers.

唯獨由側面觀察時，手指愈接近指尖部分，厚度便愈薄。

However, on the side, the thickness becomes thinner at the tip of the finger.

先抓一個與手背或手掌大致相同的寬度畫出手腕部位，分別加上拇指與小指，就能輕鬆表現出手部的體積。

By setting the area of the wrist equal to the area of the back of the hand, or the palm, and then adding the thumb and little finger, you can easily create a sense of volume.

以扇狀的曲線感，分別畫出食指
至小指指尖的位置。

Align the fingertips to the shape
of a fan that curves from the
index finger to the little finger.

繪製小指下方的手掌部分時，
應有稍微鼓起的感覺。

Draw the lower part of the
palm of the little finger a little
more convex.

繪製小指連接手腕的手掌塊狀肌群時，
應同時考慮到小指的厚度。

The little finger is connected to the wrist
by a mass on the palm.

繪製掌紋時，可大致將掌心分為豎向兩等分、橫向三等分。

Divide the palm into two equal parts horizontally and three equal parts vertically, and draw the palm lines.

手指長度
Finger length

手背長度
Length of the back of the hand

當手部加入透視時，可透過估測手掌或手背的長度與中指的長度，來調整整個手部的長度。

When drawn from different perspectives, the length of the hand is adjusted by predicting the length of the palm or back of the hand and the length of the middle finger.

手背的長度與中指長度相同，
且手背的寬度與食指長度相等。

The length of the back of the
hand is the same as the length
of the middle finger, and the
width of the back of the hand
is the same as the length of the
index finger.

由於透視的緣故難以確定手背長度時，亦可
依據手背寬度來測定手指的長度。

When it is difficult to determine the length
of the back of the hand by perspective, the
length of the finger can be predicted by the
width of the back of the hand.

當手直指著畫面時，應將手指與手指之間的間隙保留出來。根據不同的角度及動作，這個間隙可能很顯著，也可能看不見。

It is better to make space between the fingers when the hand is facing the screen. Depending on the angle and movement of the hand, this space can be greater or lesser.

手掌側面與四隻手指側面的傾斜角度應保持一致。拇指由於可移動範圍不同，角度可能有所不同。

The sides of the hand and the sides of the four fingers coincide in the angle of tilt. The thumbs have different ranges of movement, resulting in varying angles.

要掌握好手部的繪製，應使
每隻手指第一個指節的指骨
分別擁有不同的動態。

To draw hands realistically,
make sure that the first
finger bones are angled in
different directions.

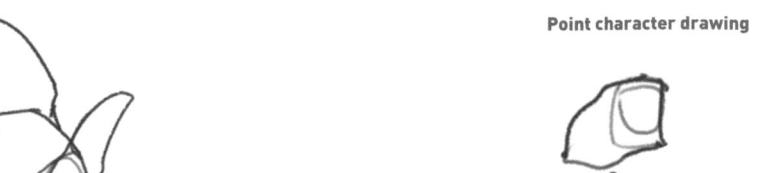

當攤開手掌、可看見掌心時，應繪製出拇指根部較隆起的肌群，並仔細區分出拇指與小指之間細微的厚度差異。

When the hand is stretched out so that the palm is visible, make sure to show the mass of the thumb and differentiate the thickness between thumb and finger.

若能意識到拇指實際上是突出於手掌
的一塊肌群，會更易於繪製。

It is easy to draw a thumb by visualizing
it as a mass protruding from the palm.

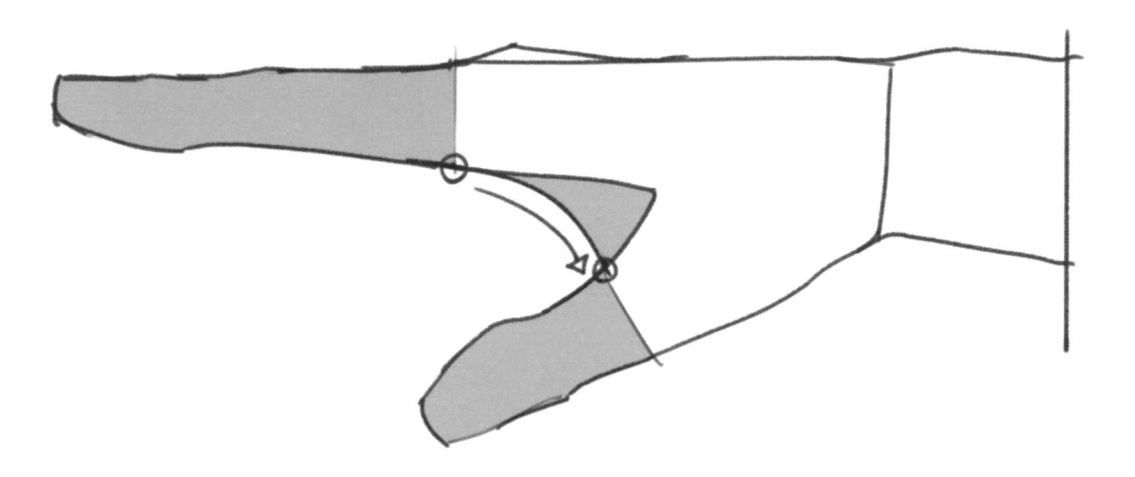

將拇指與食指展開時，拇指與食指底部的三角部位
應以曲線連接。

When the thumb and index finger are open, the
bottom edge of the thumb and index finger is
connected in a curve.

當手部平放、可看見掌心時，拇指
和小指間的肌群會彼此相連。

When laying down the hand with
the palm facing upwards, the
mass of the thumb and little finger
connects.

在表現手部動作時，若視角較接近拇指，應繪製出拇指連接手掌的肌肉線條；若視角貼近小指，則應該勾勒出小指連接手掌處的肌肉線條。

When expressing hand gestures, if the perspective is close to the thumb, draw a line on the palm attached to the thumb. And if it is close to the little finger, draw a line on the palm attached to the little finger.

繪製側面角度時，只要連接拇指和食指，再將其餘三隻手指頭畫在後方，就能輕鬆地表現出手部。

You can easily express the hand at the side angle by connecting only the thumb and index finger and drawing the other three fingers behind it.

手指突出的關節處應呈現微彎的型態。
Knuckles are drawn in a curved shape.

繪製握拳的手時，應以正面如香蕉狀彎曲的底部為基準，畫出
突出的指關節與手指，再以拇指從外側包裹起來。

As for the front of a fist the protruding bones and fingers are
drawn based on the area bent like a banana, and then the
thumb is drawn wrapping around the fist.

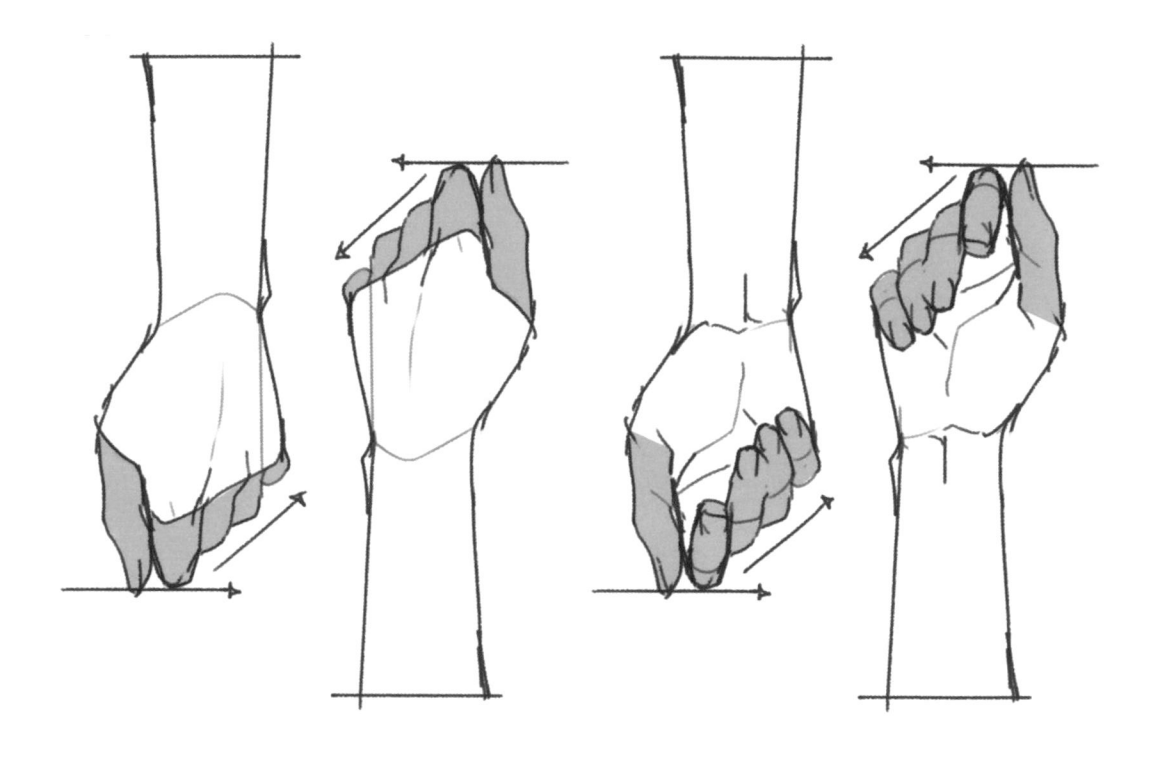

當手部放鬆、手指自然彎折時，拇指和食指的高度相同，食指至小指部分則依序逐漸變得低矮。

When the hands are relaxed and the fingers are folded, the folded thumb and index finger are the same height, and the height is gradually lowered from the index finger to the little finger.

繪製握拳的手時，應使拇指碰觸到中指。

When drawing a fist, the thumb touches the middle finger.

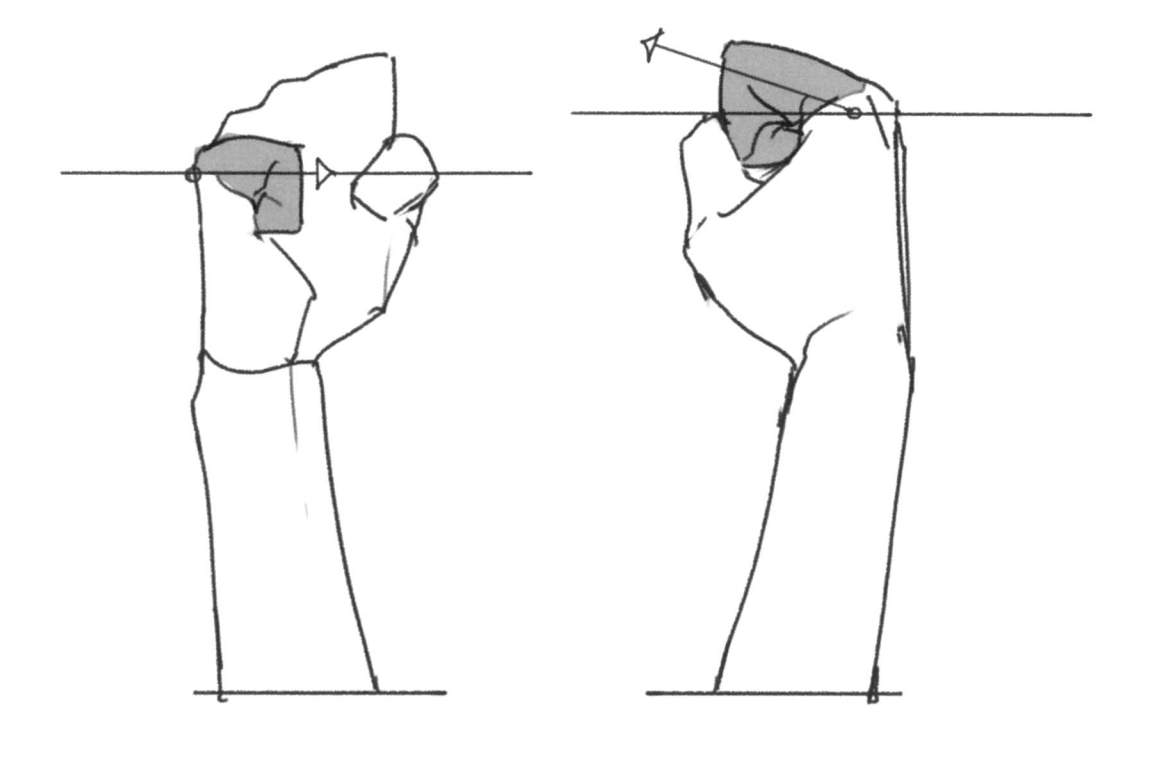

從側面觀察握拳的手，小指和食指的角度是不同的。

From the side, the fist-clasping hand differs in the angle of the little finger and the index finger.

握拳時，食指與小指的指節彎折起來，側面會呈現類似「X」字的形狀。

When a fist is clenched, the sides of the index finger and the little finger form a fold similar to 'X'.

手指的高度由中指、食指、無名指
至小指依序變低，有著細微的差異。

There are subtle differences in height
in the order of the middle finger,
index finger, ring finger, and little
finger.

先畫好弧形，就能決定手指上下
移動時的位置。

You can predict the position of
the fingers moving up and down
by drawing an arc.

手掌可劃分為三等分，其中四
邊形的位置保持不變。

The position of the square in
which the palm is divided into
three parts does not change.

指甲要畫在手指的頂面部分。

The fingernails should be drawn on the top of the finger.

將手指的遠端指節一分為二，就能掌握指甲的大小。

You can figure out the size of the fingernails by dividing the tip of the fingers in half.

拇指指甲應最大、小指的指甲最小，
其餘三指指甲的大小相近。

The thumb nail is the largest and the pinky finger nail is the smallest. The fingernails of the other three fingers are about the same size.

根據觀看角度不同，拇指與其餘四指的方向有所不同。

The direction of the thumb and four fingers differs depending on the angle of view.

繪製手指時，應強調出彎曲的關節部分，以及手指逐漸變細的輪廓。

In the case of fingers, the silhouette of the folding joints and the tip of the hand, which gradually becomes thinner, should be made clear.

繪製手指稍微彎折的狀態時，拇指和小指尖端部分
不可朝外，而是朝向內側。

When drawing folded fingers, the tip of the index
finger and the little finger creates a flow that bends
inward rather than outward.

拇指、食指、小指即使單獨移動
看起來也很自然，但中指和無名
指若單獨移動，有可能會很突兀。

The thumb, index finger, and little
finger can look natural without
being awkward even if they move
individually. The middle finger and
ring finger can be awkward when
moved individually.

當五指向中間併攏時，手掌上應沿著中指方向加入豎向的掌紋。

When fingers are gathered in the middle, place a vertical wrinkle on the palm of the hand towards the middle finger.

當指尖併攏時，食指和小指
會靠攏在中指下方，形成尖
銳的型態。

When the fingertips are
gathered, the index and
little finger are placed at the
bottom of the middle finger,
forming a sharp shape.

在能看見掌心的角度，當手指彎
起時，應以掌心的下方為中心將
指節收攏。

When the fingers are folded at an
angle where the palm is visible,
the knuckles are gathered around
the center of the palm.

當軀幹面向正面時，手部呈現側面；當軀幹呈半側面時，手部
也是半側面（位於後側的手是可看見掌心的半側面）；當軀幹呈
現側面時，手部繪製出手背的一面較為自然。

It is natural to draw the side of the hand when the body is in the
front view, the hand at a three quarter angle (for the back hand,
at a three quarter angle where the palm is visible) when the body
is in the three quarter view, and the top of the hand when the
body is in the side view.

就正面的站姿而言，手部若稍微被大腿擋住，看起來就像是手臂收在後方的姿勢，因此若非刻意表現，手部位於大腿前方會更自然。

In the front view of a standing position, if the hand is even slightly covered by the thigh, the arm is in the back position. Therefore, it is natural for the hand to come forward rather than the thigh unless that is the intended situation.

自然放鬆的狀態下，應使手部食指、中指和無名指的彎曲角度都形成些許差異。

The curved angle of the index finger, middle finger, and ring finger are all different when a hand is in a relaxed position.

當手指之間形成小小的縫隙時，以曲線連接較佳。

When making small connections between fingers, it is better to draw them in curves.

當手指伸展時，接縫處以小
三角形模樣相連會更自然。

When the fingers are spread
apart, it is more natural
to make the connections
between them in the form of
a small triangle.

當手指伸直的時候，若將旁邊手指的指節稍微抬起，會顯得更自然。

When drawing an open finger, you can express it more naturally by slightly lifting the joint of the next finger(s).

當手指直指向前時，貼近畫面的遠端指節應畫出如
香蕉般彎曲的型態。

The tip of the finger that extends close to the screen
is drawn curved like a banana.

若將小指稍稍抬起、略高於無名指，就能凸顯出纖細的感覺。

Raising the little finger above the ring finger creates a delicate impression.

握拳時，只要稍稍提高食指指節，
動作就會顯得更豐富、不單調。

A hand balled into a fist can be
given volume by lifting the joint of
the index finger slightly.

繪製手掌握拳的正面部分時，在小指與食指邊緣處留出空間，就能表現出立體感。

To create a three-dimensional effect when drawing the front part of the fist, include spaces on the edges of the index and little fingers.

手指動作的表現非常多樣，表現手部動作時，留意手指不要超出可移動範圍即可。

There are many different ways of expressing moving fingers. You can create finger movements while taking care not to deviate from the range.

當手部顯得僵直，或是手指很難表現時，只要稍微改變食指的動作，都能使手部表現更豐富。

By changing the flow of the index finger a little, you can prevent the hand from looking stiff and more easily draw the other fingers.

用手掌支撐地面時，使手指
稍微彎曲起來會更自然。

When touching the ground
with the palm, it is natural for
the fingers to bend slightly.

當手指接觸物體時，比起基本可彎曲的範圍，手指可再彎折得更多一些。

When a finger touches an object, it bends more than it would otherwise bend.

若想表現手部施力的感覺，可看見手掌時就強調出手腕處的骨骼線條；可看見手背時，就凸顯出手背上的骨骼線條。

To express a hand with force, you can draw a skeleton line on the wrist when the palm is visible and on the back of the hand when the back of the hand is visible.

手部舒展時，只要將指尖處提高、彎折，
就能感受到力度。

When drawing an open hand, you can feel
the force by bending the tip of the fingers
slightly upwards.

十指交握時，第一個指節處
的關節模樣會有些許不同。

The shape of the first joint
of the fingers changes when
interlacing the fingers.

手部叉放在腰際的姿勢，可以彎折手腕，以整個手背接觸腰部，或者可讓整個手掌貼合著腰部輪廓來繪製。

For the posture of placing the hand near the waist, bend the wrist so that the entire back of the hand touches the waist or the entire palm is drawn along the waist silhouette.

繪製正面角度、手持桿狀物的手
部動作時，須畫出手指突出於桿
子上方的厚度。

When drawing a hand holding a
bar at a frontal angle, draw a gap
between the fingers equivalent
to the thickness of the fingers on
the bar.

根據持握物體的厚度不同，可見
的手指長度也不同。

The length of the fingers seen
from the front varies depending
on the thickness of the object
held in the hand.

隨著拇指彎折的角度不同，可以表現出抓握物體時力道的差異。

The angle at which the thumb is bent can express the difference in hand strength when holding an object.

繪製持筆的手部動作時，將拇指和食指指尖相對，預留放置筆桿的空間即可。

When drawing a hand holding a pen, you need to make the tips of the thumb and index finger touch each other, and create a space for the pen between them.

抓握球狀物體時，可根據手掌的
位置以及支撐物體的手指不同，
表現出力道強弱的差異。

When grabbing a round object,
strength is expressed according
to the position of the palm and
the fingers supporting the object.

韓國繪師的
角色繪製重點攻略— vol.1

出　　　　版／楓書坊文化出版社

地　　　　址／新北市板橋區信義路163巷3號10樓

郵 政 劃 撥／19907596　楓書坊文化出版社

網　　　　址／www.maplebook.com.tw

電　　　　話／02-2957-6096

傳　　　　真／02-2957-6435

作　　　　者／崔元喜

翻　　　　譯／林季妤

責 任 編 輯／王綺

內 文 排 版／楊亞容

港 澳 經 銷／泛華發行代理有限公司

定　　　　價／320元

出 版 日 期／2022年9月

國家圖書館出版品預行編目資料

韓國繪師的角色繪製重點攻略／崔元喜作；
林季妤翻譯. -- 初版. -- 新北市：楓書坊文化
出版社, 2022.09　　面；　公分

ISBN 978-986-377-798-4（第1冊：平裝）

1. 人體畫　2. 繪畫技法

947.2　　　　　　　　　　111010533